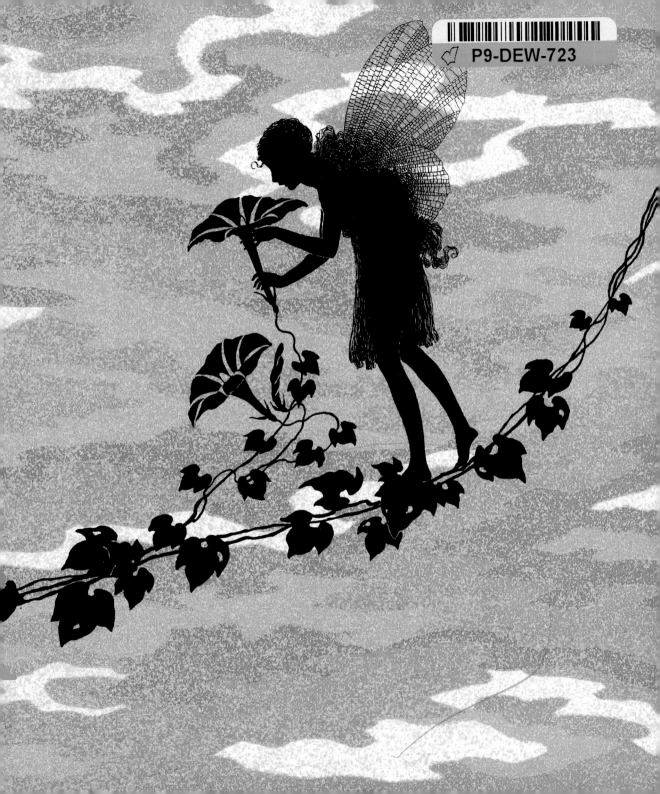

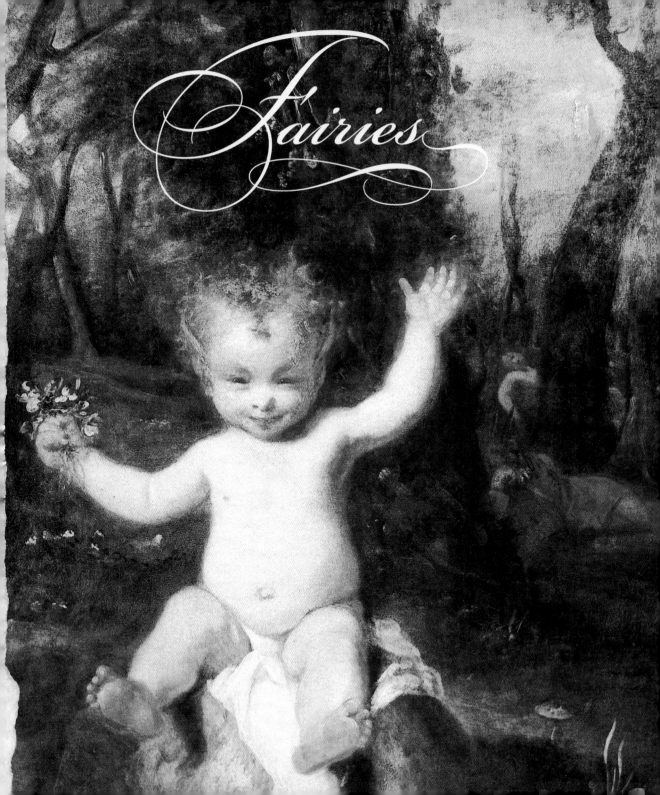

Fairies

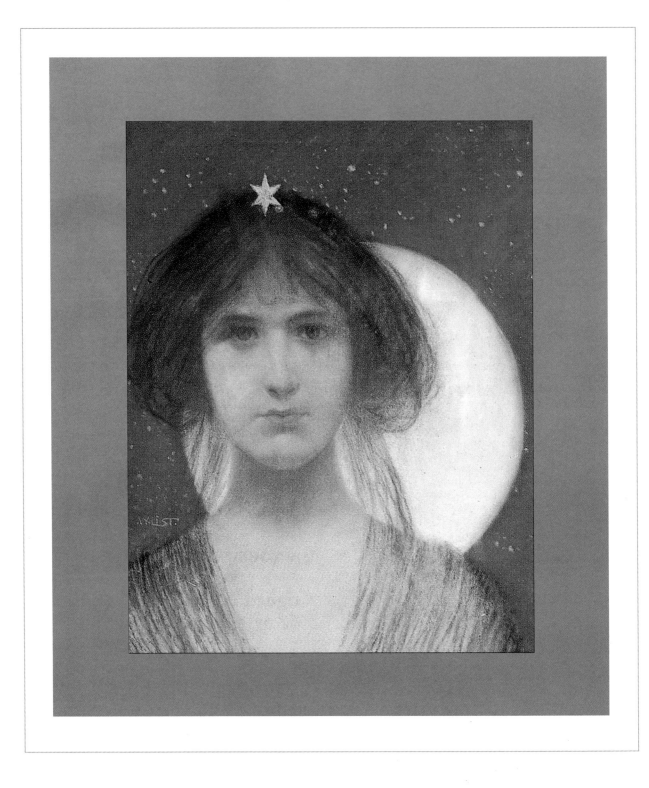

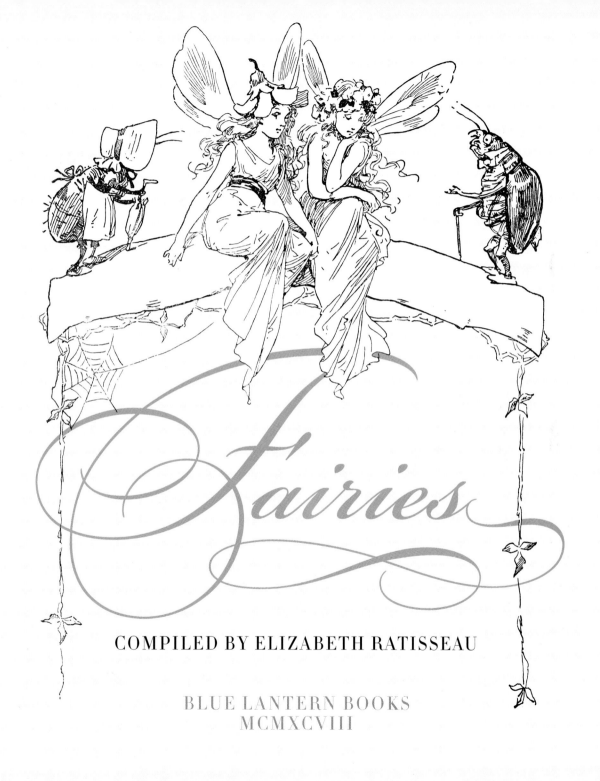

Fairies

COMPILED BY ELIZABETH RATISSEAU

BLUE LANTERN BOOKS
MCMXCVIII

ISBN 1-883211-12-3

Book design by Sacheverell Darling at Blue Lantern Studio.

Blue Lantern Books
PO Box 4399 Seattle Washington 98104

Fairies

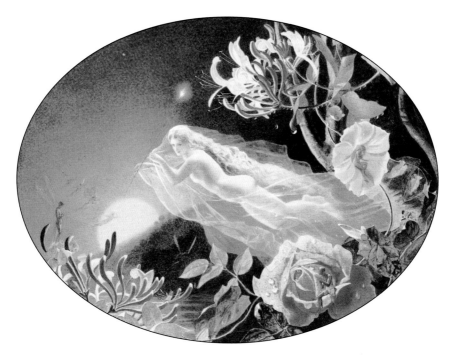

Of all the minor creatures of mythology the fairies are the most beautiful, the most numerous, the most memorable in literature.

Andrew Lang

Fairies are generally regarded as of a nature between spirits and men, or as spirit beings with the semblance of a body. In many aspects they are like mankind. They have their occupations, amusements, fightings. They marry and bear children. But they have powers beyond those of ordinary mortals, yet like those attributed to medicine-men, sorcerers, and witches. They are regarded as a separate race of superior beings, as many of their titles suggest – 'fair or still folk,' 'people of peace,' etc.

J.A. MacCulloch

Then clear on a flute of purest gold
A sweet little fairy played,
And wonderful fairy tales she told,
And marvelous music made.

Ida Rentoul Outhwaite

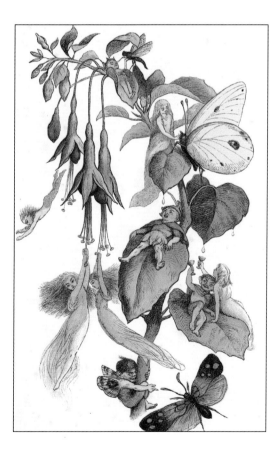

Play takes the form of jumping and skipping, peeping curiously into birds' nests, and taking an interest in all the show of life about. The fairies know all neighboring birds and animals personally, and show deep concern in all their doings. The sense of mischief is well-developed, and practical jokes are going on all the time. One fairy will steal into another's area and be found demurely doing their neighbor's rightful jobs, only to be hustled out gaily. They have a power of hypnotic suggestion over animals which makes a rabbit or squirrel miss a bit of food which he starts out to get. These antics are just fun and the animals are not irritated or really teased.

Dora van Gelder

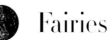

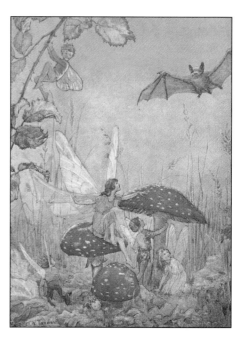

The woods are full of fairies!
 The trees are all alive:
The river overflows with them,
 See how they dip and dive!
What funny little fellows!
 What dainty little dears!
They dance and leap, and prance and peep,
 And utter fairy cheers!

 'A'

Persons in a short trance-state of two or three days' duration are said to be away with the fairies enjoying a festival. The festival may be very material in its nature, or it may be purely spiritual. Sometimes one may thus go to Faerie for an hour or two; or one may remain there for seven, fourteen, or twenty-one years. The mind of a person coming out of Fairyland is usually a blank as to what has been seen and done there. Another idea is that the person knows well enough all about Fairyland, but is prevented from communicating the knowledge. A certain woman of whom I knew said she did remember, and wouldn't tell. A man may remain awake at night to watch one who has been to Fairyland to see if that one holds communication with the fairies. Others say in such a case that the fairies know you are on the alert, and will not be discovered.

Walter Evans-Wentz

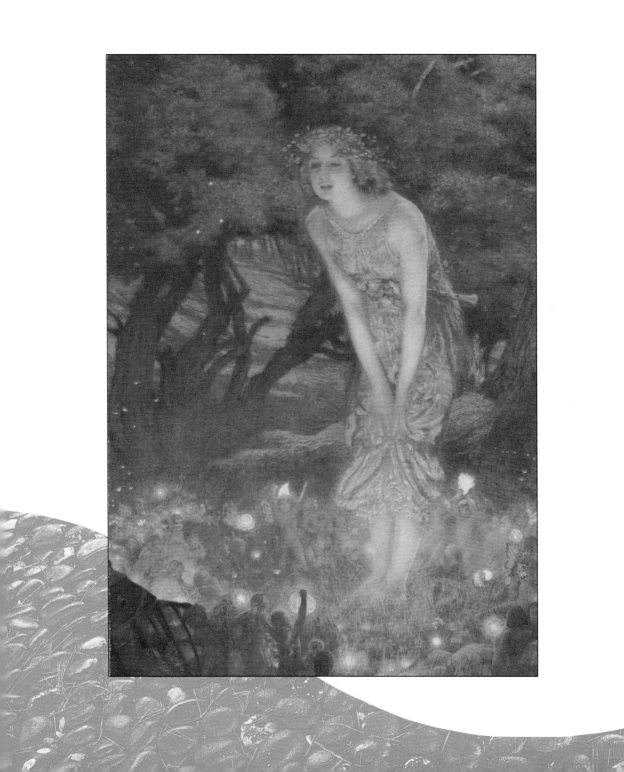

> 'Twas I that led you through the painted meads,
> Where the light fairies danced upon the flowers,
> Hanging on every leaf an orient pearl.
>
> *Thomas Steevens*

One of them has observed us and does not seem to be afraid. She is holding her light filmy garment, through which the pink and white form is just discernible, up with her right hand, and in her left she carries some object, which for the moment I cannot describe; the limbs are bare, the hair is long and hangs loose, tiny lights play like a garland round her head, and so beautiful is her carriage, that, were it not for the complete absence of self-consciousness and the perfect candor shown in the expression of face and eyes, I should have thought she was posing.

Geoffrey Hodson

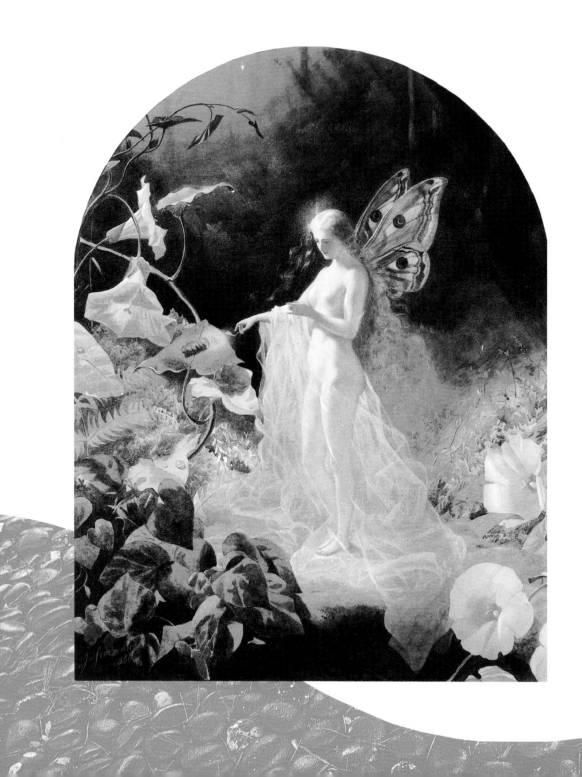

Air Fairies

Fairies, arouse!
 Mix with your song
Harplet and pipe,
 Thrilling and clear.
Swarm on the boughs!
 Chant in a throng!
Morning is ripe,
 Waiting to hear.

William Allingham

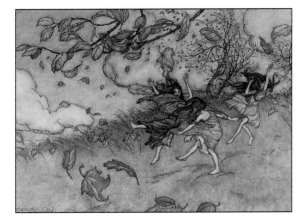

There might be a dozen of them, the biggest about three feet high, and small ones like dolls. Their dresses sparkled as if with spangles, like the girls at shows at Stow fair. They were moving round hand in hand in a ring, no noise came from them. They seemed light and shadowy, not like solid bodies. I passed on saying, the Lord have mercy upon me, but them must be fairies, and being alone then on the path over the field could see them as plain as I do you.

As told by a Stowmarket man in Hollingsworth's History of Suffolk

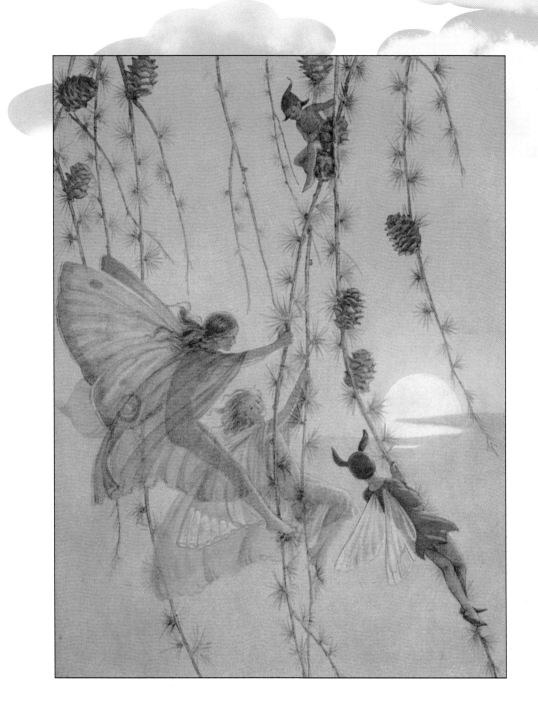

Air Fairies

John Beaumont, talking to fairies in the eighteenth century, asked them once what manner of creatures they were. They told him that they were 'of an Order of Creatures Superior to Mankind and could Influence our Thoughts, and that their Habitation was in the Air'. The Scottish pastor Robert Kirk, who wrote *The Secret Commonwealth of Elves, Fauns, and Fairies* in 1691 and who was reputed to have been 'taken' by fairies for giving away their secrets and for having the temerity to walk over a fairy knoll, wrote that: 'These siths or Fairies, are said to be of middle Nature, betwixt Man and Angel, as were Daemons, thought to be of old; of intelligent, studious Spirits, and light changeable Bodies (lyke those called Astral) somewhat of the Nature of a condensed cloud, and best seen in the Twilight. These bodies be so pliable through the subtilty of the Spirits that agitate them, that they can make them appear and disappear att Pleasure.'

J.C. Cooper

Queen, and huntress, chaste, and fair,
Now the sun is laid to sleep,
Seated, in thy silver chair,
State in wonted manner keep:
 Hesperus, entreats thy light,
 Goddess, excellently bright.

Ben Jonson

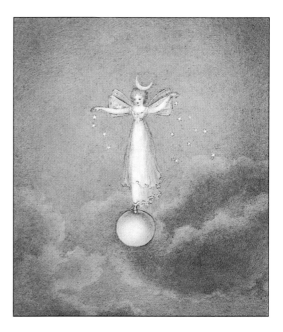

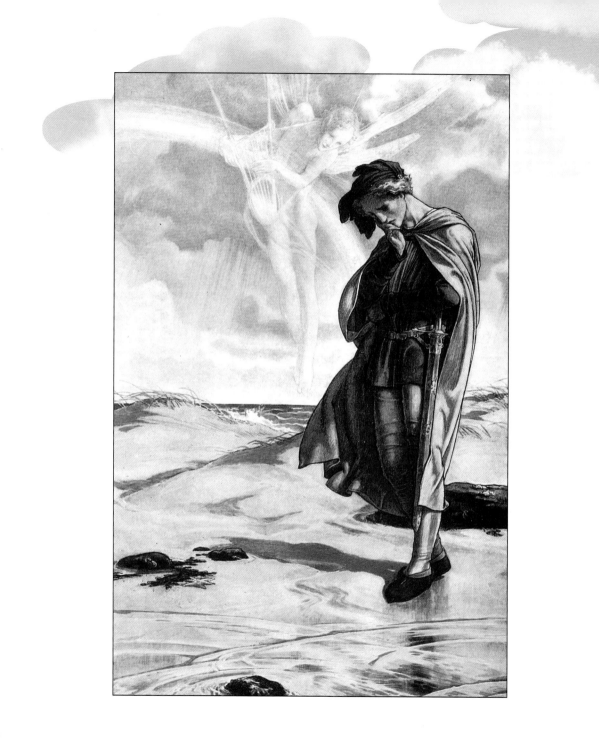

Air Fairies

And they are elfin mariners
 Who stand at prow and helm;
By mortal eye unseen, they hie
 From many an airy realm.

Florence Harrison

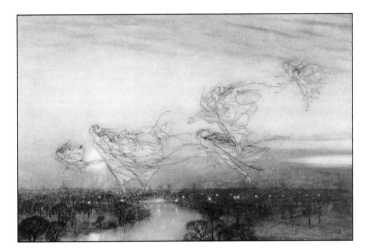

The opalescent beings seem to be about fourteen feet in stature, though I do not know why I attribute to them such definite height, since I had nothing to compare them with; but I have always considered them as much taller than our race. The shining beings seem to be about our own stature or just a little taller. Peasant and other Irish seers do not usually speak of the Sidhe as being little, but as being tall: an old schoolmaster in the West of Ireland described them to me from his own visions as tall beautiful people, and he used some Gaelic words, which I took as meaning that they were shining with every colour.

Walter Evans-Wentz

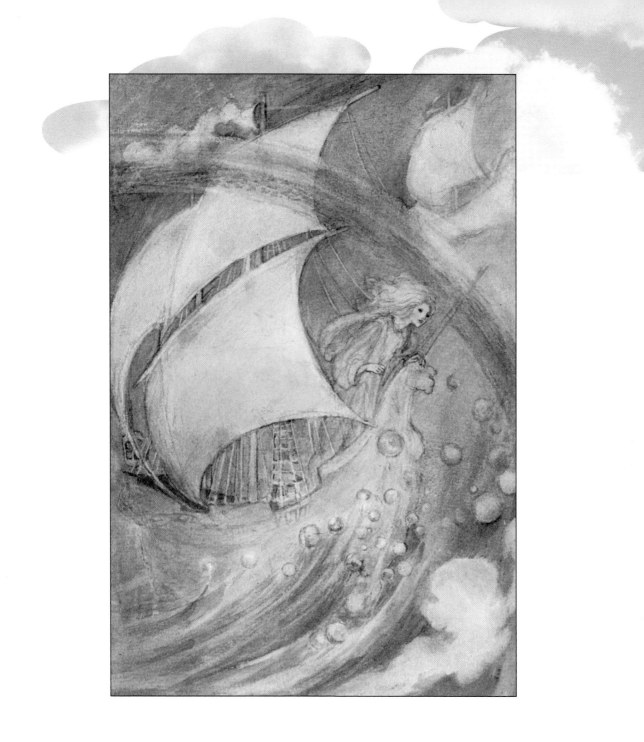

Air Fairies

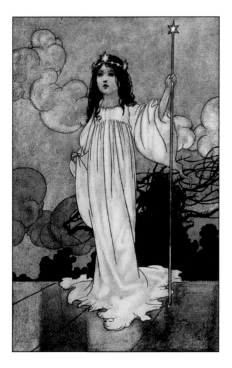

The wall is silence, the grass is sleep,
Tall trees of peace their vigil keep,
And the Fairy of Dreams, with
moth-wings furled,
Plays soft on her flute to the
drowsy world.

Ida Rentoul Outhwaite

These California races are said to exist now, as the Irish and Scotch invisible races are said to exist now, by seers who can behold them; and, like the latter races, are described as a distinct order of beings who have never been in physical embodiments.

Walter Evans-Wentz

She is aware of our presence and has graciously remained more or less motionless for the purpose of this description. She holds up her wand, which is about the length of her forearm, and is white and shining and glows at the end with a yellow light.

Geoffrey Hodson

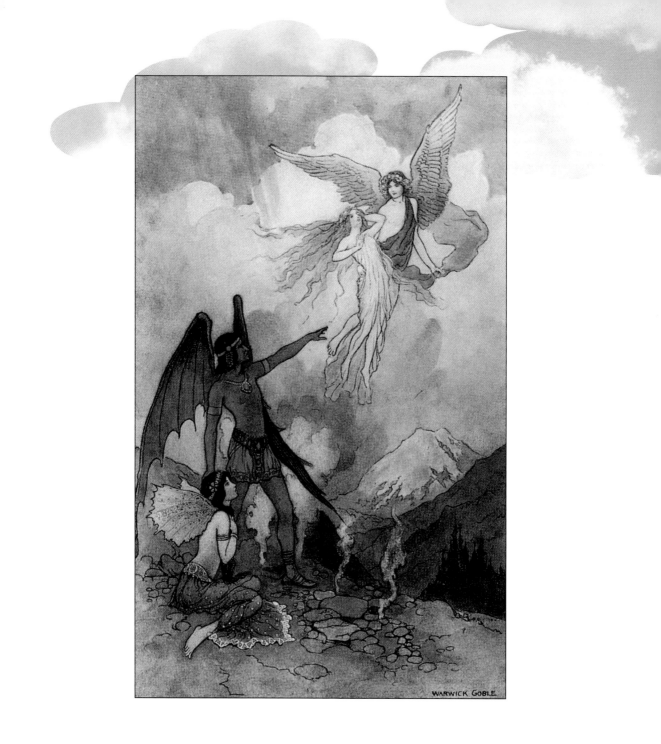

WARWICK GOBLE.

Fire Fairies

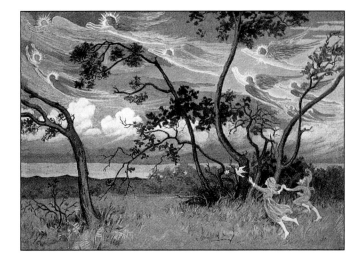

Feed apace then, greedy eyes,
One the wonder you behold:
Take it sudden, as it flies,
Though you take it not to hold.
When your eyes have done their part
Thought must length'n it in the heart.

Samuel David

Q. – Can you describe the shining beings?
A. – It is very difficult to give any intelligible description of them. The first time I saw them with great vividness I was lying on a hill-side alone in the west of Ireland, in County Sligo: I had been listening to music in the air, and to what seemed to be the sound of bells, and was trying to understand these aerial clashings in which wind seemed to break upon wind in an ever changing musical silvery sound. Then the space before me grew luminous, and I began to see one beautiful being after another.

Walter Evans-Wentz

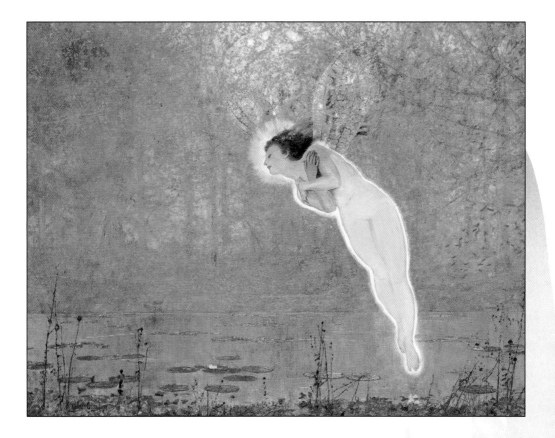

Fire 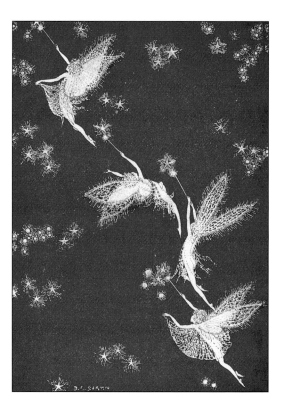 Fairies

I saw a star slide down the sky,
Blinding the north as it went by,
Too burning and too quick to hold,
Too lovely to be bought or sold,
Good only to make wishes on
And then forever to be gone.

Sara Teasdale

The skies in their magnificence,
 The lovely, lively air,

Oh how divine, how soft, how sweet,
 How fair!
The stars did entertain my sense.

Thomas Traherne

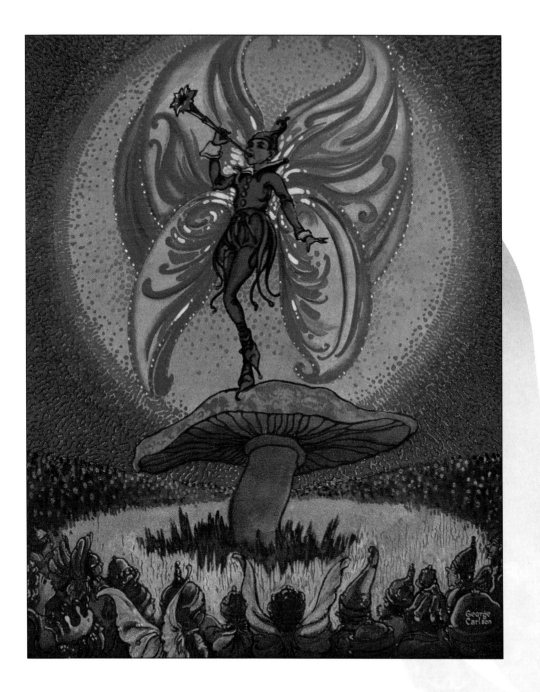

Fire Fairies

I looked across the river and saw a circle of supernatural light...The spot where the light appeared was a flat space surrounded on the sides away from the river by banks formed by low hills; and into this space and the circle of light, from the surrounding sides apparently, I saw come in twos and threes a great crowd of little beings smaller than Tom Thumb and his wife. All of them, who appeared like soldiers, were dressed in red. They moved back and forth amid the circle of light, as they formed into order like troops drilling.

Kelleher

There was at first a dazzle of light, and then I saw that this came from the heart of a tall figure with a body apparently shaped out of half-transparent or opalescent air, and throughout the body ran a radiant, electrical fire, to which the heart seemed the centre. Around the head of this being and through its waving luminous hair, which was blown all about the body like living strands of gold, there appeared flaming wing-like auras. From the being itself light seemed to stream outwards in every direction; and the effect left on me after the vision was one of the extraordinary lightness, joyousness, or ecstasy.

Walter Evans-Wentz

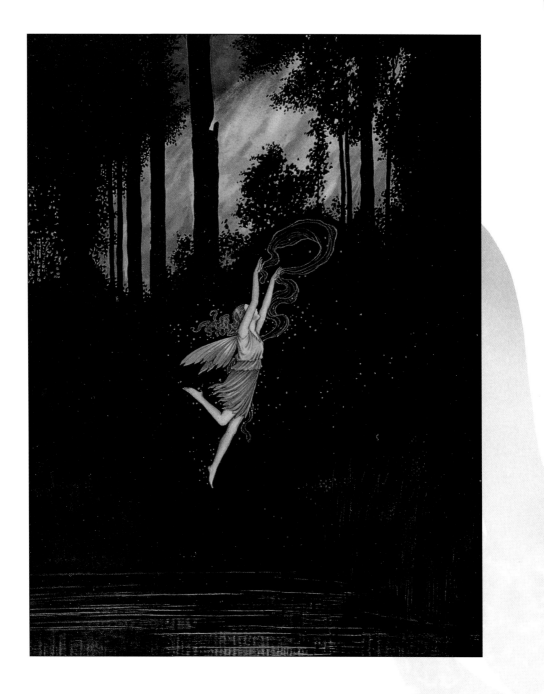

Water Fairies

There are three chief classes of water spirits – the patrons of wild life, the personified forces of Nature, and the localized spirits which haunt particular rocks, waters and woods.

K.M. Briggs

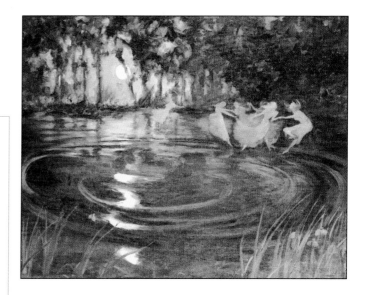

From gray woods they come,
 on silent feet
Into a cone of light.
A lifting note,
O fair! O fleet!

There the night through
 We take our pleasure,
Dancing to such a measure
 As earth never knew.

Seumus O'Sullivan

Their lovely clothes were milky white
And never yet there struck my sight
Beings so excellently bright. . . .

Romance of King Orfeo

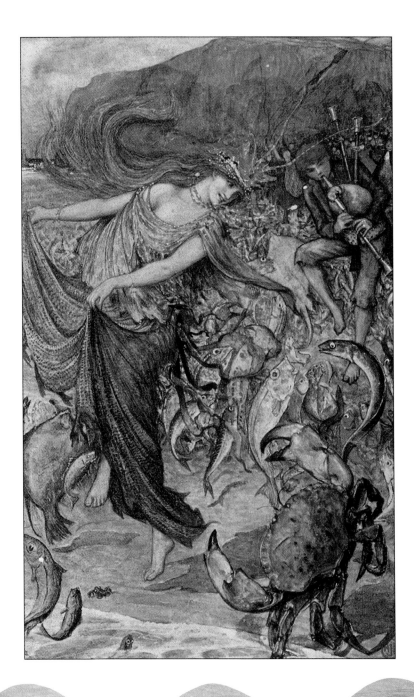

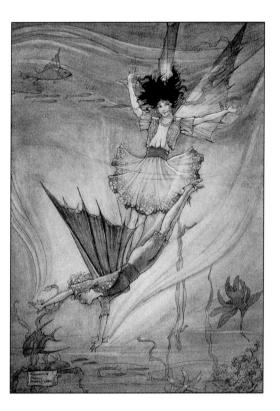

I ride on the crest of the wave,
I swim through the ocean's deep.
I sail through the blue,
 the glorious blue,
And sometimes ride
 on the storm cloud too,
And follow the lightning's leap.

Matilda Hutchinson Turner

Dominating the feelings of the fairies that inhabit the surface of the sea is the fact that rhythm, which plays so large a part in the lives of all fairies, is for them embodied in the physical rhythm of the waves. . . . In the case of the water fairies, the waves give them a fine feeling of effectiveness. They are in constant movement like the surface of the sea itself, and just as the sea is one great mass in which there is not much differentiation of material, so the fairies of the sea are a homogeneous band.

Dora van Gelder

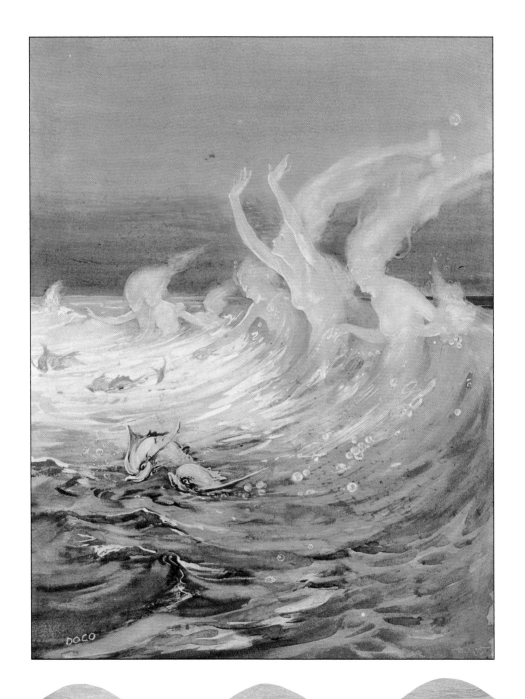

Water Fairies

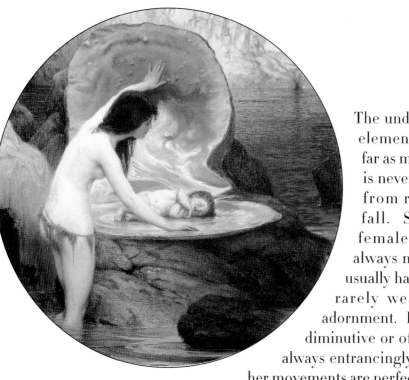

The undine belongs to the element of water and, so far as my experience goes, is never to be found away from river, stream and fall. She is definitely female in form and is always nude; she does not usually have wings, and only rarely wears any kind of adornment. Her form, whether diminutive or of human stature, is always entrancingly beautiful, and all her movements are perfect...

... In the ocean shallows there are sea-nymphs, in shape just like a human woman and of radiant beauty. They are not winged like the land-fairies. They live in colonies both under and on the surface of the sea which is their home. Riding on its waves and sometimes sinking into its depths, they pass a joyous existence. I see them calling to each other in loud voices, crying in exultation as the life-forces, of which they are composed, arouse in them almost unimagined joy. These, as well as the smaller sea-fairies, are much more keenly alive, much more strenuous in their existence than their land brethren.

Geoffrey Hodson

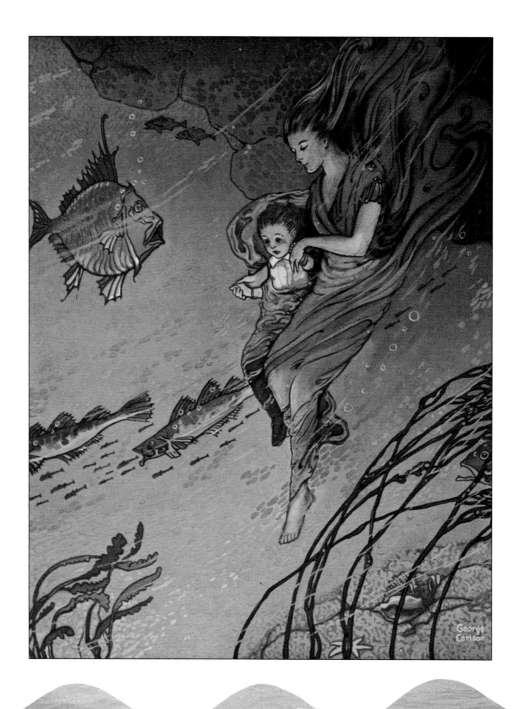

Water Fairies

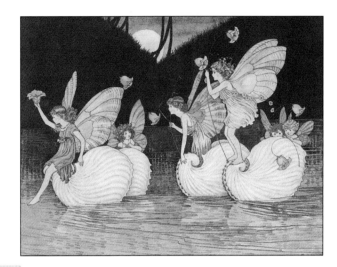

Her father was a rivulet,
Her mother was a fay.
Her lineaments, so fine that were,
She from the fairy took;
Her beauties and complexion clear
By nature from the brook.

Michael Drayton

My palace is in the coral cave
Set with spars by the ocean wave;
Would ye have gems, then seek them there, –
There found I the pearls that bind my hair.
I and the wind together can roam
Over the green waves and their white foam, –

See, I have got this silver shell,
Mark how my breath will its smallness swell,
For the Nautilus is my boat
In which I over the waters float:
The moon is shining over the sea, –
Who is there will come and sail with me?

L.E. Landon

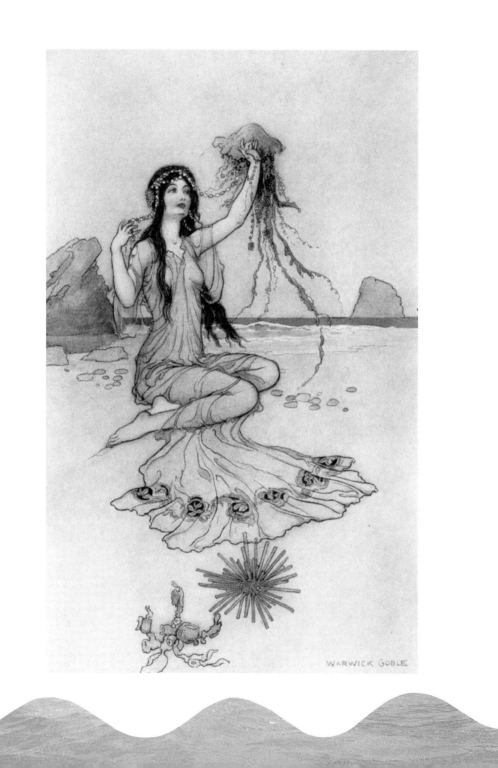

WARWICK GOBLE

Fairies of Childhood

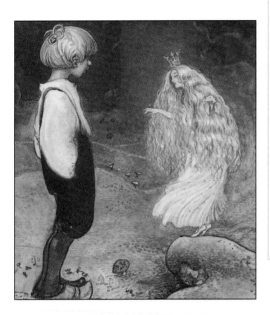

I must follow in their train
Down the crooked fairy-lane
Where the coney-rabbits long ago have gone
And where silverly they sing
In a moving moonlit ring
All a-twinkle with the jewels they have on.
They are fading round the turn
Where the glow-worms palely burn
And the echo of their padding feet is dying!
O! it's knocking at my heart –
Let me go! O let me start!
For the little magic hours are all a-flying.

J.R.R. Tolkien

In childhood the relationship between the two kingdoms is closer than at any other time of life. This is because children are closer by nature to fairies than any other human beings. They are naturally happy, and spontaneous in action; they fit well into nature; they are also somewhat irresponsible, with few worries about food and clothing, and they have a remarkable capacity for finding delight, fascination and creative joy in little things like a pebble or a shell or an empty box. They also take an intense interest in young and growing things, are boundlessly curious about everything within range, have not consciousness of conventional traditions of behavior or moralities, love adventure, dressing up and tales of mystery and imagination. In all these ways children are close to the fairies in character. This is why in childhood the gates are so often open and the human-fairy worlds are so completely one.

Dora van Gelder

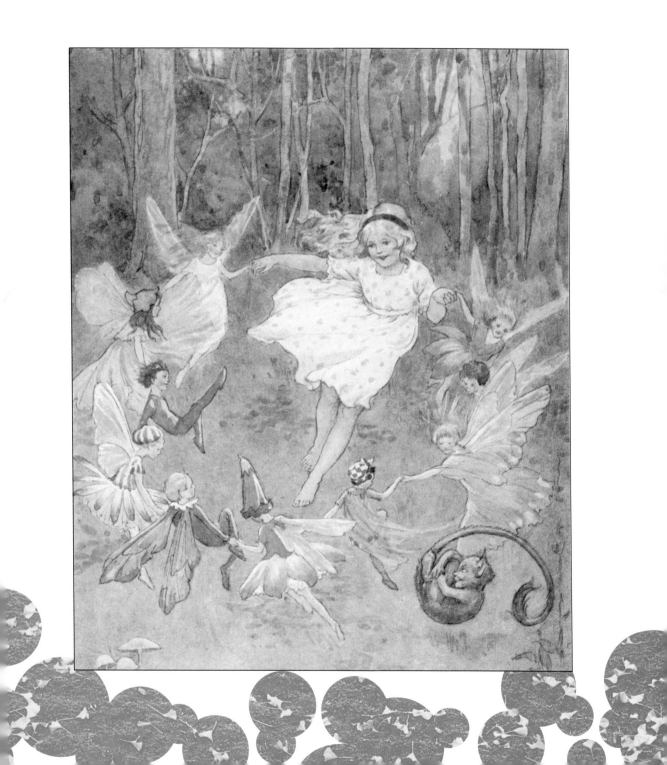

Fairies of Childhood

They love to visit girls and boys
 To see how sweet they sleep,
To stand beside their cosy cots
 And at their faces peep.
For in the whole of fairy land
 They have no finer sight
Than little children sleeping sound
 With faces rosy bright.

Robert M. Bird

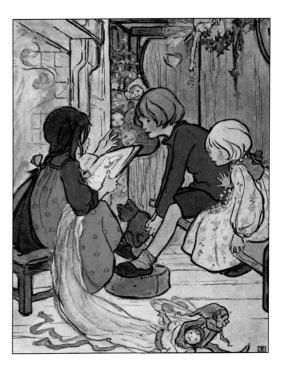

The little Plumpuppets are fairies of beds:
They have nothing to do but to watch sleepy heads;
They turn down the sheets and they tuck you in tight,
And they dance on your pillow to wish you good night!

Christopher Morley

Hobgoblin was formerly a polite title for the friendly domestic fairies; though the word has lately gained rather a sinister sound. This type of fairy is known all over Europe, and appears again and again in both the Celtic and the Saxon folk lore of the British Isles.

K.M. Briggs

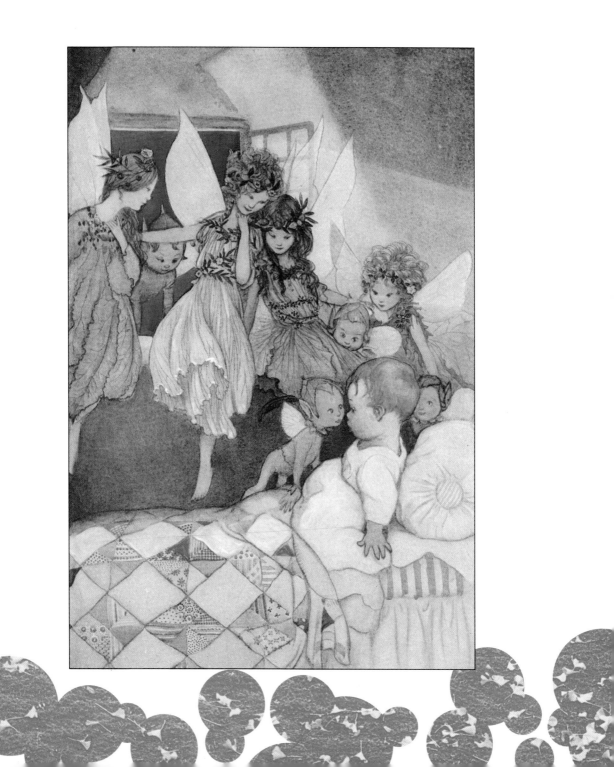

Fairies of Childhood

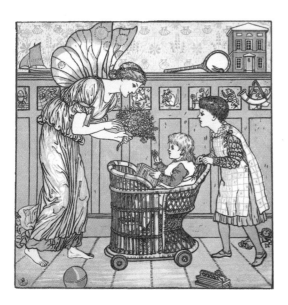

Upon the terrace where I play
A little fountain sings all day
 A tiny tune;
It leaps and prances in the air –
I saw a little fairy there
 This afternoon.

Rose Fyleman

Fairy-god-mothers are one of the many kinds of fairies dedicated to helping humanity. Countless times fairies assist with household tasks such as sweeping and washing. Outside they plant and harvest. These tasks are almost always performed in secret, and as a surprise. Fairies also like to make gifts – particularly gold, magic vessels and finely woven cloth. Fairy-god-mothers are different in that they appear and negotiate their bestowals. They help people out of dilemmas, rescue them from perils, provide them with needed information, and use their transformational power to fulfill the human's aspirations.

Welleran Poltarnees

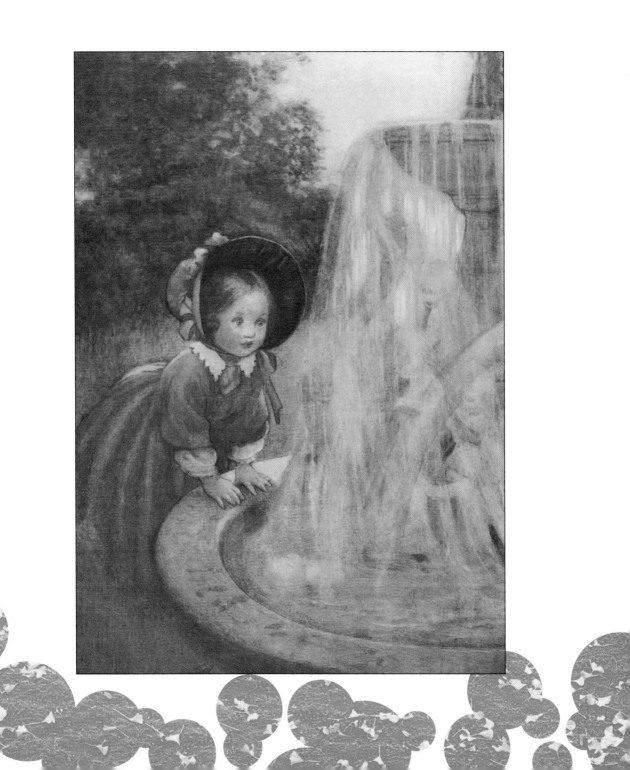

Fairies of Childhood

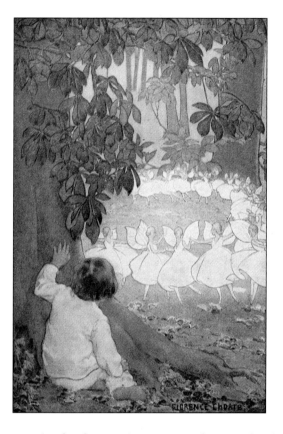

The soft stars are shining,
　　　　The moon is alight;
　　The folk of the forest
　　Are dancing tonight:
　　　　O swift and gay
　Is the song that they sing;
　　　　They float and sway
　　As they dance in a ring.

Katherine Davis

Music also has an important place in the fairy world. It has always had spell-binding associations, from the yore of Orpheus and Apollo, the pipes of Pan, the charms of Cadmus, the spells of the Sirens, to the Magic Flute, the Pied Piper of Hamelin, and on to such tales as Sweetheart Roland, where the wicked witch is forced to dance to the music until she drops dead. Music can also lull into an enchanted sleep. In the Kalevala, sleep is induced by a magic song and in Greek and European tales the flute and violin have magical life-restoring qualities. In the East the power of music to charm is well known and widespread. But all fairies dislike loud noise.

J.C. Cooper

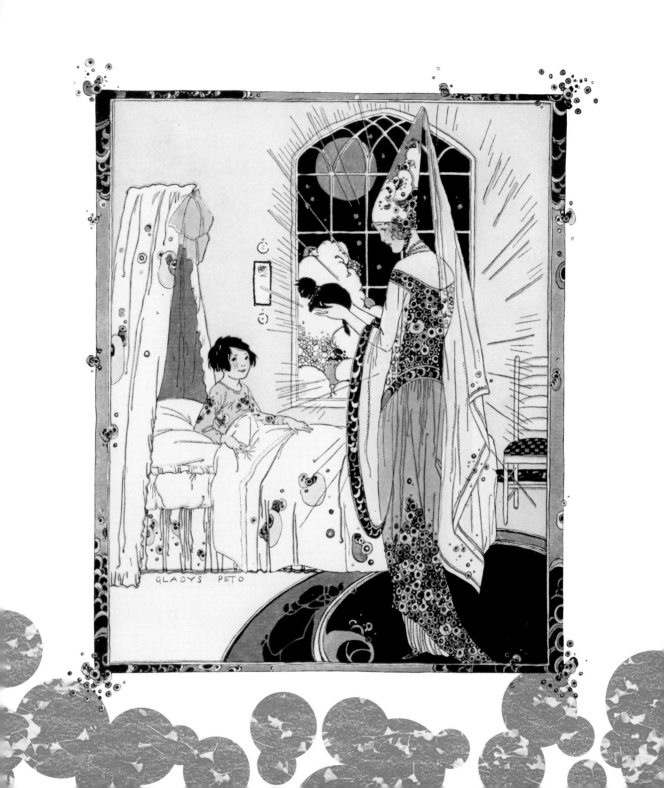

Fairies of Childhood

I met a little Elfman once,
 Down where the lilies blow.
I asked him why he was so small,
 And why he didn't grow.

He slightly frowned, and with his eye
 He looked me through and
through –
"I'm just as big for me," said he,
 "As you are big for you!"

John Kendrick Bangs

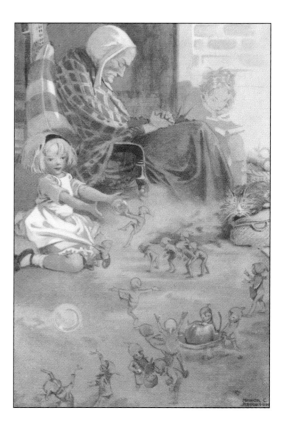

I was seated in the middle of a road in some cornfields, playing with a group of pop-pies, and never shall I forget my utter astonishment at seeing a funny little man playing hide-and-seek amongst these flowers to amuse me, as I thought.

Miss Hall

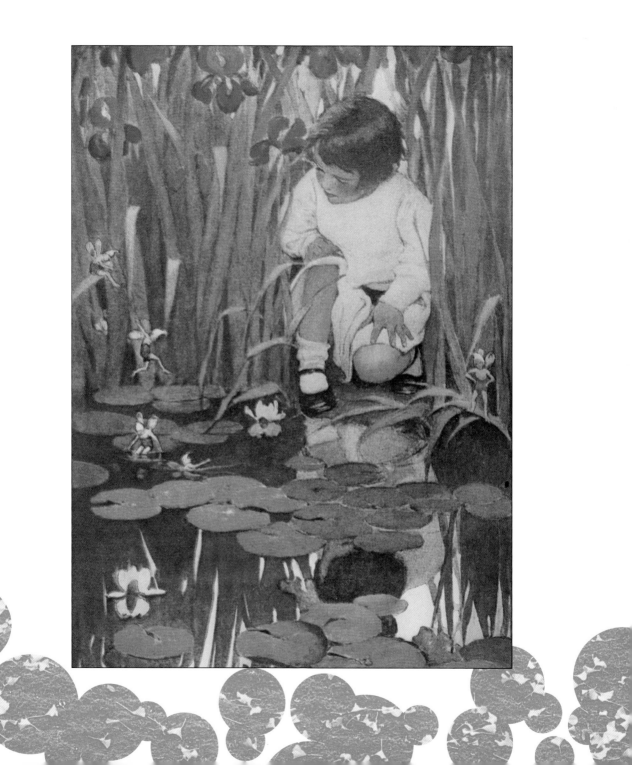

Fairies of Childhood

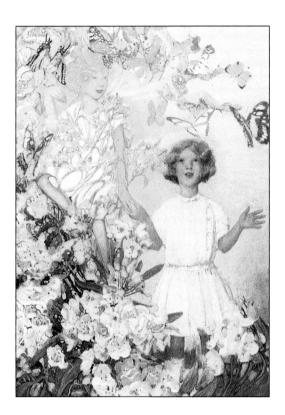

There are fairies at the bottom
 our garden!
They often have a dance
 on summer nights;
The butterflies and bees make
 a lovely little breeze,
And the rabbits stand about and
 hold the lights.
Did you know that they could sit
 upon the moonbeams
And pick a little star to make a fan,
And dance away up there in the
 middle of the air?
Well they can.

Rose Fyleman

Stories of fairies embody all that is romantic, wistful and melancholy - the sudden fear and aching longing for lost worlds, strange countries, dreams of beauty beyond the mundane imperfections of here and now...In the magic private world of the child and the vision of the mystic there are more enduring truths than the chapter and verse of the skeptic or the flashy ephemeral gains and losses of the material world.

Leslie Shephard

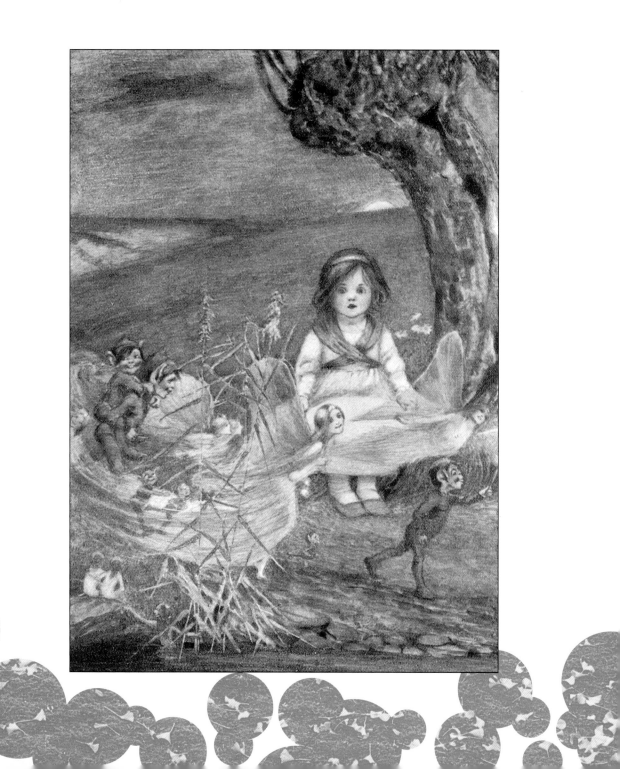

Picture Credits

Cover	Warwick Goble. from *The Book of Fairy Poetry*, 1920.
Half title	Sir Joshua Reynolds. "Puck," 1789.
Frontis	Wilhelm List. "A Night Fairy," n.d.
Title page	Harriet M. Bennet. from *Sunny Land Stories*, 1921.
4	C.F. Neagle. Advertisement, 1920.
5	John Simmons. "Titania Flying," 1866.
6	Richard Doyle. from *In Fairyland: A Series of Pictures from the Elf-World*, 1875.
7	Etheline E. Dell. "Fairies and a Field Mouse," circa 1880's.
8	Margaret W. Tarrant. from *Ward Lock & Co's Wonder Book*, 1926.
9	Edward Robert Hughes. "Midsummer Eve," n.d.
10	Florence Anderson. from *The Dream Pedlar*, 1914.
11	John Simmons. "Titania", 1866.
12	Arthur Rackham. from *Peter Pan in Kensington Gardens*, 1906.
13	Margaret W. Tarrant. "Elfin Swings," n.d.
14	Amelia Jane Murray. untitled, circa 1820's.
15	Paul Woodroffe. from *The Tempest*, 1908.
16	Arthur Rackham. "Twilight Dreams," 1912.
17	Florence Harrison. from *Elfin Song*, 1912.
18	Charles Robinson. from *Brownikins and Other Fancies*, 1910.
19	Warwick Goble. from *The Book of Fairy Poetry*, 1920.
20	Estella Canziani. from *Songs of Childhood*, 1923.
21	John Atkinson Grimshaw. "Iris," 1886.
22	D.C. Burton. from *Cassell's Children's Annual*, 1909.
23	George Carlson. from *The Magic Stone*, 1917.
24	Ethelwynne M. Quail. from *Kingdom of the Gods*, 1952.
	By kind permission of The Theosophical Publishing House, Adyar, Madras, 600 020, India
25	Ida Rentoul Outhwaite. from *Fairyland*, 1929.
26	Arthur John Black. "Fairies' Whirl," circa 1880's
27	Henry J. Ford. from *The Lilac Fairy Book*, 1910.
28	Florence Mary Anderson. from *The Cradle Ship*, 1916.

29 Doco. "The Neptune Stakes," n.d.

30 Herbert James Draper. "A Water Baby," 1900.

31 George Carlson. from *The Magic Stone*, 1917.

32 Ida Rentoul Outhwaite. from *Elves and Fairies*, 1916.

33 Warwick Goble. from *The Book of Fairy Poetry*, 1920.

34 John Bauer. from *Bland Tomtar Och Troll*, 1907.

35 Margaret W. Tarrant. from *In Wheelabout and Cockalone*, 1918.

36 Florence Harrison. from *The Big Book of Pictures and Stories*, circa 1920.

37 Bessie Pease. Printed ephemera, n.d.

38 Walter Crane. from *The Baby's Bouquet*, 1879.

39 Anonymous. Printed ephemera, n.d.

40 Florence Choate. from *365 Bedtime Stories*, 1923.

41 Gladys Peto. from *Gladys Peto's Children's Annual*, circa 1930.

42 Honor C. Appleton. from *The Book of English Verse: A Treasury of Verse for School and Home*, 1926.

43 Jessie Willcox Smith. from *The Way to Wonderland*, 1917.

44 Sarah S. Stilwell. from *The Child in Fairyland*, circa 1910.

45 Millicent Sowerby. from *Yesterday's Children*, 1908.

47 Anonymous. from *Fun and Thought For Little Folk*, n.d.

Back Cover E.B. Bensell. from *The Absent-Minded Fairy*, 1884.

Principal Sources

Celtic Folklore: Welsh and Manx, Sir John Rhys. Oxford University Press, 1901.

Fairies at Work and at Play, Geoffrey Hodson. Theosophical Publishing House, 1925.

The Fairy Faith In Celtic Countries, W. Y. Evans - Wentz. H. Frowde, 1911.

The Fairy Mythology, Thomas Keightley. G. Bell, 1878

Fairy Tales, Allegories of the Inner Life, J.C. Cooper. The Aquarian Press, 1983.

The Real World of Fairies, Dora van Gelder. Theosophical Publishing House, 1977.

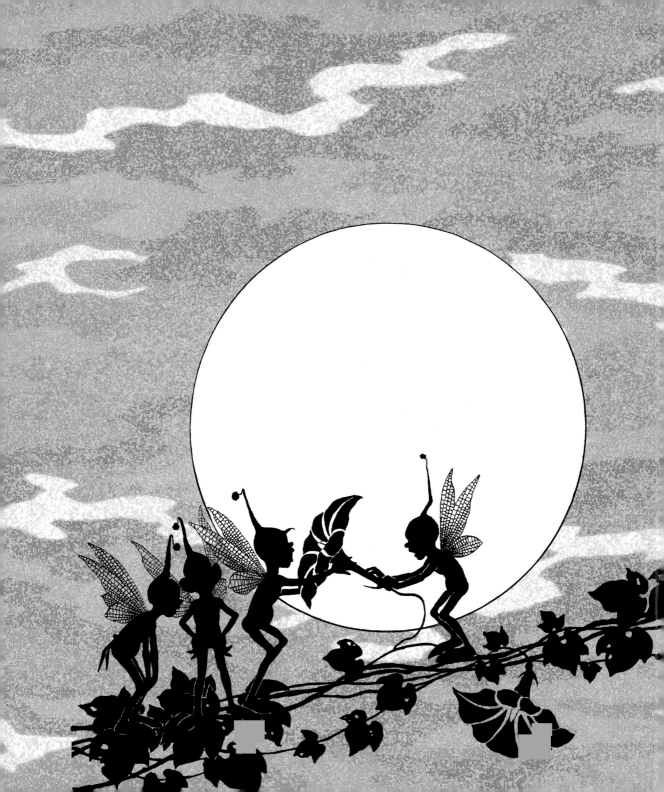